16

Hip
Hop
Hares

and Other Moments of
Epic Silliness

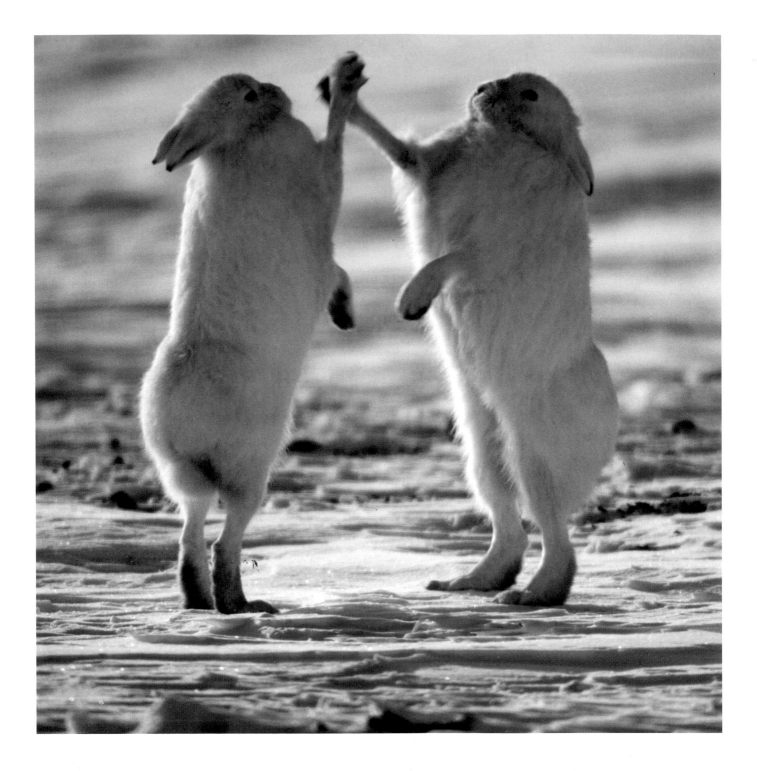

Hip Hop Hares

and Other Moments of Epic Silliness

More Classic Photographs from
Outside Magazine's "Parting Shot"

from the editors of *Outside*

Introduction by Bill Vaughn

W. W. NORTON & COMPANY
NEW YORK • LONDON

Photo permissions: Accent Alaska: 80; Alaska Stock: 28, 65; Corbis: 19, 25, 29; Corbis SABA: 71; Eyevine: 58; Focus Productions: 72; Getty Images: 32, 77; Jump Photo Archive: 45, 48; Magnum Photos: 12, 61, 67, 94; Minden Pictures: 14, 15, 33, 35, 55, 79, 85; National Geographic Image Collection: 21; Peter Arnold: 31, 34, 62, 93; Peter Arnold/UNWEP: 63; Photonica: 24, 54; Workbookstock.com: 82, 87.

Copyright © 2004 by Mariah Media Inc.

For information about permission to reproduce selections from this book, write to
Permissions, W. W. Norton & Company, Inc., 500 Fifth Avenue, New York, NY 10110

Manufacturing by South China Printing Co. Ltd.
Book design and photo sequencing by BTDNYC
Photography director: Rob Haggart
Photo editor: Edie Dillman
Production manager: Andrew Marasia

Library of Congress Cataloging-in-Publication Data
Hip hop hares and other moments of epic silliness : more classic photographs from Outside magazine's "Parting Shot" /
from the editors of Outside ; introduction by Bill Vaughn.
p. cm.
ISBN 0-393-32515-6 (pbk.)
1. Photography humorous. 2. Outdoor Photography. I. Outside (Chicago, Ill.)

TR679.5.H577 2004

779—dc22

2004049258

W. W. Norton & Company, Inc., 500 Fifth Avenue, New York, N.Y. 10110
www.wwnorton.com

W. W. Norton & Company Ltd., Castle House, 75/76 Wells Street, London W1T 3QT

1 2 3 4 5 6 7 8 9 0

Talking Pictures
Bill Vaughn

CAPTURED BY THE CAMERA, a male and a female gaze into the middle distance with that expression of neurotic bafflement common among large territorial animals confined to a cage. Outside, a dad leans fearlessly against the bars, pointing at the beasts, as he shares with his kid darker aspects of their behavior. "They foul their own nests, son, they eat everything in sight, and whenever they migrate to a new area they force all the other species out."

I concocted this rather derivative *Planet of the Apes* story for my own amusement in order to narrate the evocative and mysterious image shown on the left. Or how about this, instead? A diner in a restaurant points into a holding pen at the entrée choices and says to the waiter, "These look good, but do you have anything free-range?"

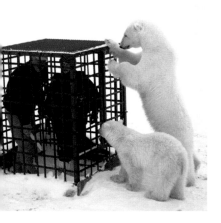

I felt compelled to make up these scenarios because, like all of the goofy, startling, dizzying, and wonderfully inexplicable photos in this collection, the only thing we learn from the note accompanying Michio Hoshino's polar bear picture, "Churchill, Canada," is the "where" part of that old journalistic edict, but not the who, what, when, or why. Like most Americans, I'm a control freak and a news junky who craves instant information. So the scarcity of w's was maddening at first. What's happening? I wanted to know. What does this picture *mean*?

But as I studied this photo, and then the entire gallery of images, I realized something. When you see a photograph strong enough to stand alone, one that

doesn't resort to some pedantic, newspaper-style cutline to sell itself, the picture has the effect of a funhouse mirror that lets you alter and shape what you're seeing any way you want. As you try to fill in the blanks, your imagination is engaged and your participation in the image becomes mandatory.

The editors of *Outside* intended it that way, imagining these "Parting Shot" photographs, which have been published almost every month since 1979 on the concluding page of the magazine, as conversation starters and not as the end of the discussion. Supplying the location is simply meant to reassure us that these events, however they might be translated, are real. To look at this editorial decision from another angle, think of it this way: although photographs are never entered as evidence at trial without a witness explaining to the judge and jury what they're seeing, the law also recognizes the power of some things to do their own explaining. The legal moniker for self-evidence is *res ipsa loquitur,* Latin for "the thing speaks for itself."

It's easy to let certain of these images talk about themselves because they portray such antic and fleeting events in the natural world that any explanation would just be a lame human guess. Take the Arctic hares high-fiving, for example. Or the elephant submerged in an African river, only its trunk breaking the surface. Or the bear cub on its hind legs in the woods, dancing all alone. Seeing these, I'm reminded of Bryan Di Salvatore's philosophy of camping, which he once wrote about in *Outside*: "Take only photographs, leave only footprints." Then he advised: "Reverse this process." Di Salvatore's advice is a *koan,* an unanswerable Zen riddle in the spirit of "what's the sound of one hand clapping?" Just like these photographs, *koans* are meant to elicit wonder and perplexity and eventually illumination.

And then there are action shots of daredevils that urge us to care about their fate, or at least wonder what it's going to be. Here's a runner soaring dozens of feet in the air after leaping off one side of a deep ravine. You hope he's aiming at the other side, and that he makes it. You also hope that the water at the bottom of the ravine is deep enough to cushion his fall. And here's a photo shot from directly overhead showing a kayak swept along by whitewater; it's surging violently through a stone defile so narrow that the kayaker must hold the paddle above his head parallel to the boat.

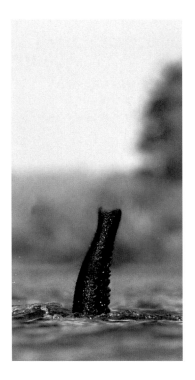

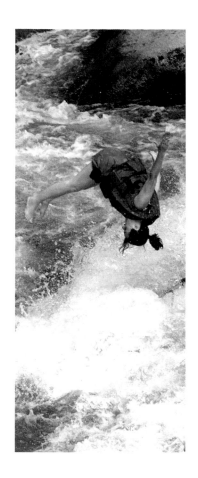

The more pulsing and gut-wrenching of the images in this collection elicit what *Outside* photography editor Rob Haggart calls a "holy shit moment." One of these finally wore down my resolve to let these pictures speak their native tongue. Falling off the wagon, I dialed the photographer with a trembling hand. The photo in my other hand showed a woman suddenly catapulted from the rear of a raft that's careening through turbulent green water. The rock walls of the river look murderous, and her helmetless, pony-tailed head looks vulnerable. Strangely, her means of exit is a high back flip so graceful and controlled and athletic it would earn her at least a 9.5 at the summer Olympics. It's clear she was thrown from the raft, and didn't bail out, because someone's billfold is also airborne, as is a white plastic bucket.

"Did she survive?" I asked the photographer, Charlie Munsey, who took this picture at the end of a stretch of Class III rapids one recent summer on the North Fork of the Payette River in western Idaho.

"Yeah, she's fine," he said. "Although she was under for ten seconds or so before they drifted into a pool and could pull her back in the boat."

The raft hit a wave launch, he explained, a melodramatic fit of turbulence that can sling unbattened rafters around like a carnival ride. Some experienced river dawgs enjoy being trampolined in this manner, positioning themselves so they're heaved straight up by the force of the wave. The woman in Munsey's picture, however, never knew what hit her. She was launched ten feet into the air, completed a flawless reverse somersault, and knifed into the water feet first. But why the circus act? Why didn't she brace herself or flinch?

"Well, no one on board was feeling any pain," Munsey said. "This was a party barge."

Haggart said this gripping illumination is one of those "right place, right time, film-in-the-camera kind of shots" that he loves and constantly seeks, and which only a unique breed of photographer seems able to harvest. These are artists, he said, who never go anywhere without a camera, and are always on high alert for situations that might generate the motion and buzz and wonder of the natural world, which the readers of *Outside* have come to expect from the magazine's photographs. Part of this talent is timing, part of it is experience, and part of it is the gift of anticipation. Although an element of luck is also involved, this

is the sort of good fortune generated by perseverance. Consequently, the "Parting Shot" is a rare bird, an image almost always taken by professionals.

It's taken me years, but I've finally come to appreciate the art and skill of picture taking on the wing. Although I always carry a camera in the field when I'm researching an article, the more I shoot the more I'm convinced that, while an infinite number of monkeys pounding away at an infinite number of typewriters might theoretically reproduce the complete works of Shakespeare, give the same beasts Nikons and they'd never come up with anything but dreck.

The most recent of my efforts as a photographer produced stacks of unpublishable color snapshots showing sacred Indian pictographs in Wyoming, the tip of my finger edging into almost every frame. And there are grotesque shots of ghost towns and virgin prairie in North Dakota, the eerie shadow of a man holding a camera dominating the foreground. This fuzzy lump with a palm tree? That's Pulau Tiga, the Malaysian island where the first season of the CBS mega hit *Survivor* was filmed, a picture I took from a fishing boat during a storm as brine from the South China Sea seeped into my 35mm Canon from Costco. Going back much further, to college, there's a photo essay I shot at a pig farm that represented my attempt to illustrate the assigned topic: Love. I called the essay "Porcine Eros: Threat or Promise?" The grade I received for this out-of-focus and weirdly composed collage was a D.

My energetic but clumsy affair with a camera was consummated the moment I began clicking away on a decent-quality Leica I got one Christmas when I was a kid. My first subject was Danny, my Labrador retriever cross. The surreal portraits I composed of him showed chickens and cats and potted tomatoes apparently riding around on his back, and bushes and the rails of fences growing from his head. Looking at these images now, it strikes me that they disobey every possible convention of composition and framing and lighting. But all my hapless photographic mutts, from childhood on, share one thing in common with the highbred champions in this collection: It doesn't matter what these images might mean to others, because, finally, I know exactly what they're saying to me.

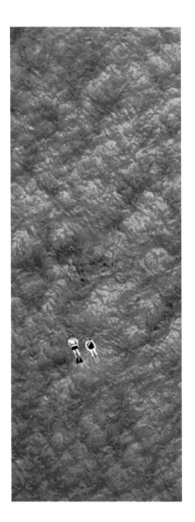

Hip
Hop
Hares

and Other Moments of
Epic Silliness

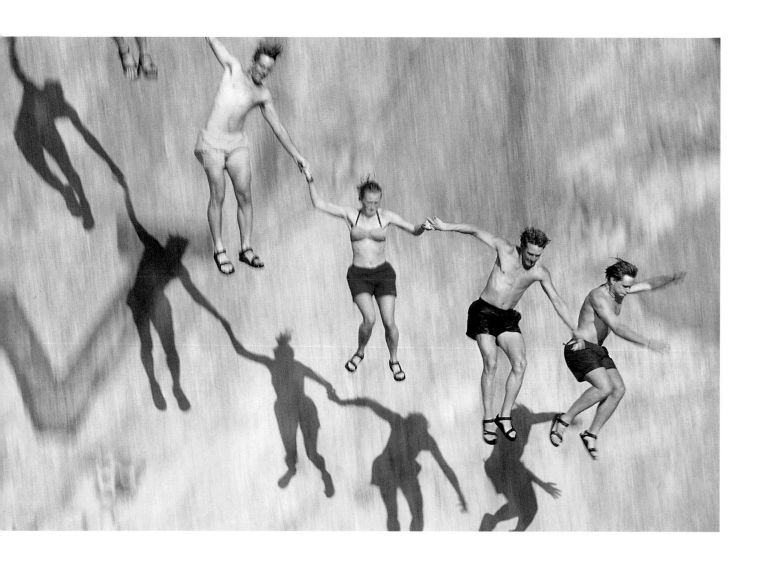

Snake River, Washington

SCOTT SPIKER

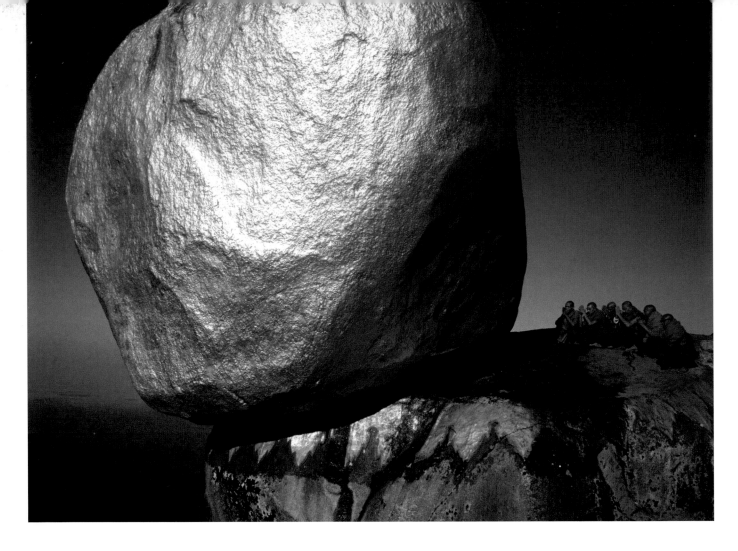

Kyaikto, Burma

HIROJI KUBOTA

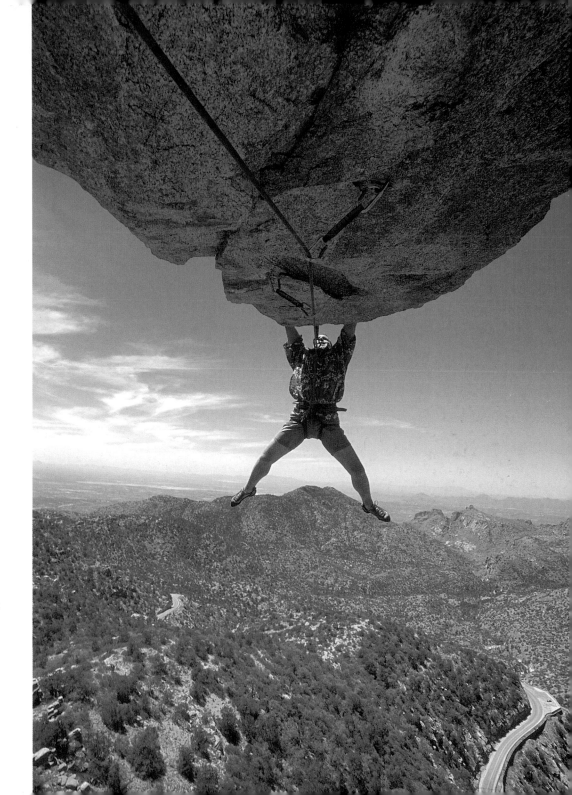

Mount Lemmon,
Arizona

ANDREW KORNYLAK

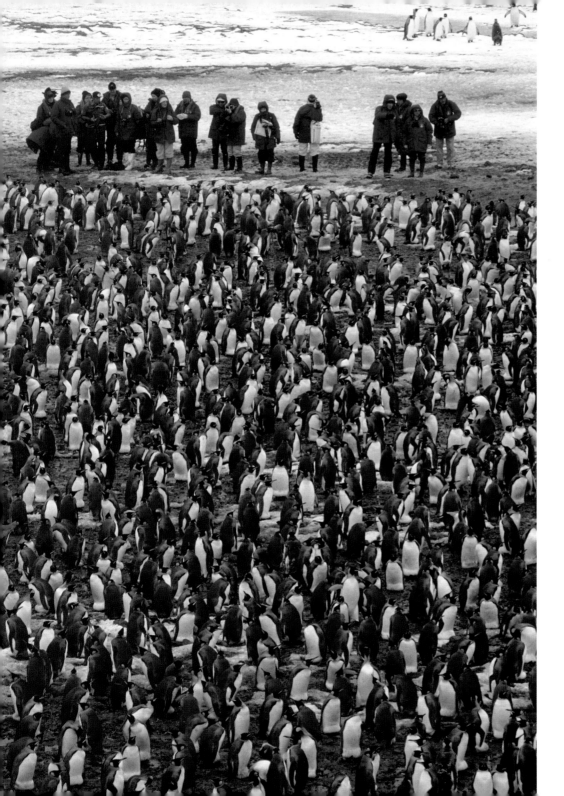

South Georgia,
Falkland Islands

FRANS LANTING

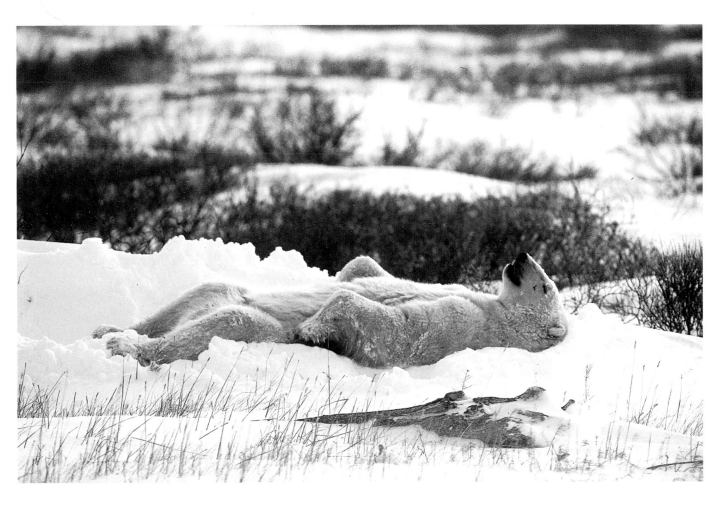

Hudson Bay, Manitoba, Canada

BARRY GORDON

Kipsjärvi, Finland

WILLIAM FINDLAY

Hudson Bay, Manitoba, Canada

BARRY GORDON

Kipsjärvi, Finland

WILLIAM FINDLAY

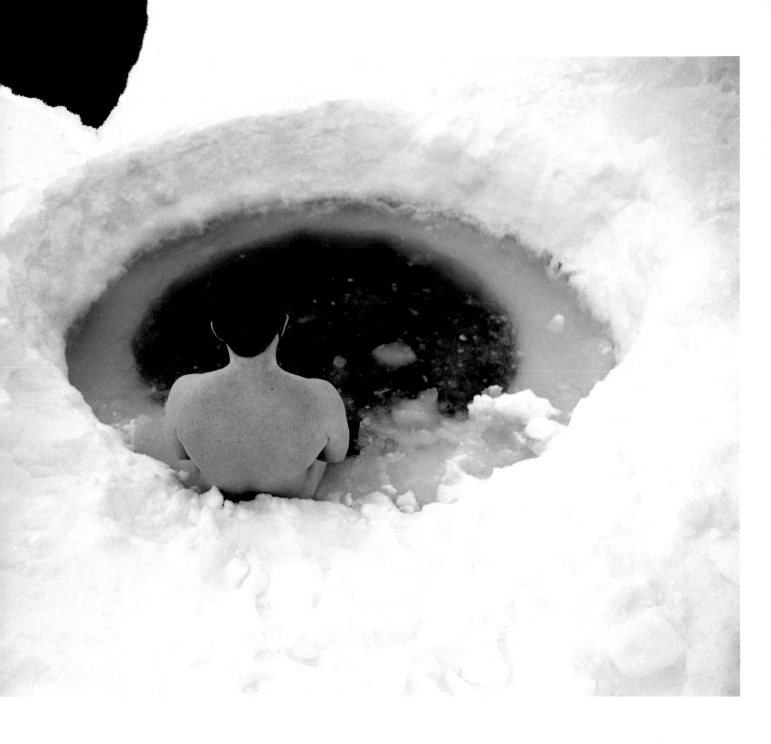

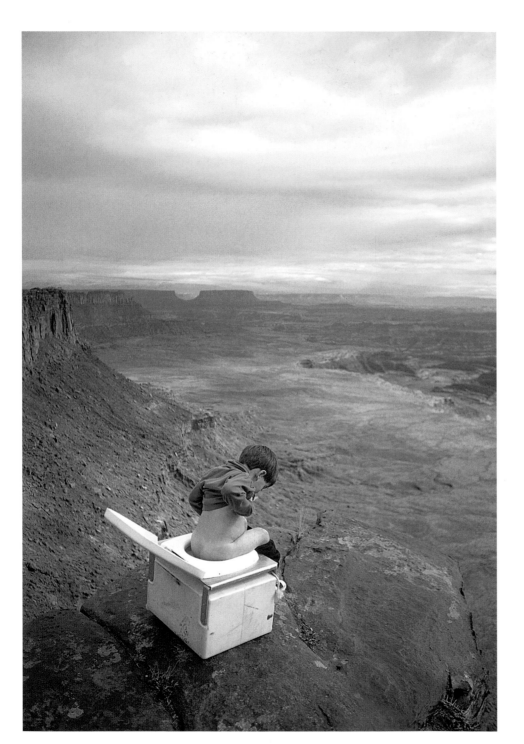

**Canyonlands
National Park, Utah**

LEE COHEN

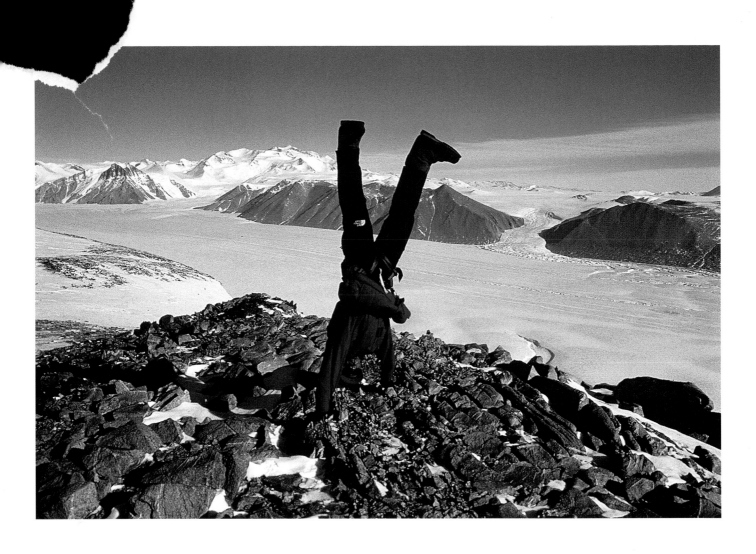

Victoria Land, Antarctica

MARIA STENZEL

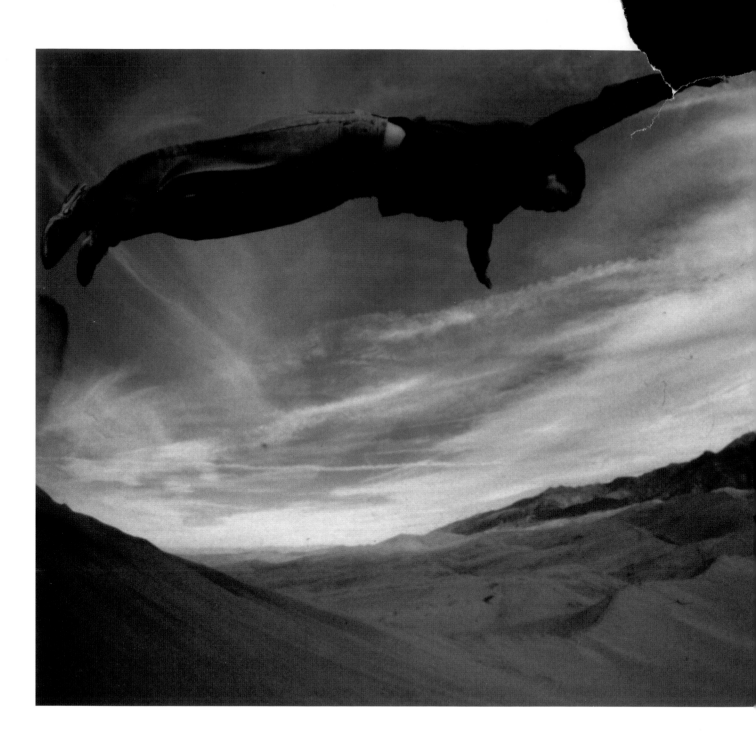

**Great Sand Dunes
National Monument,
Colorado**

GABE ROGEL

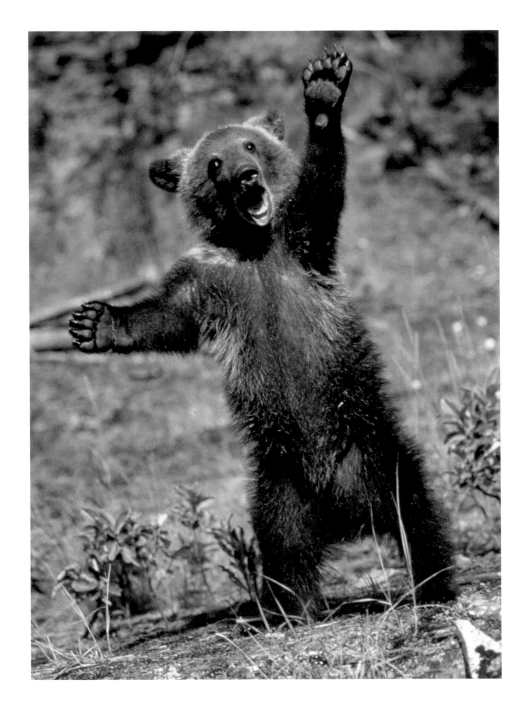

**Flathead River,
Montana**

ZEFA BIOTIC

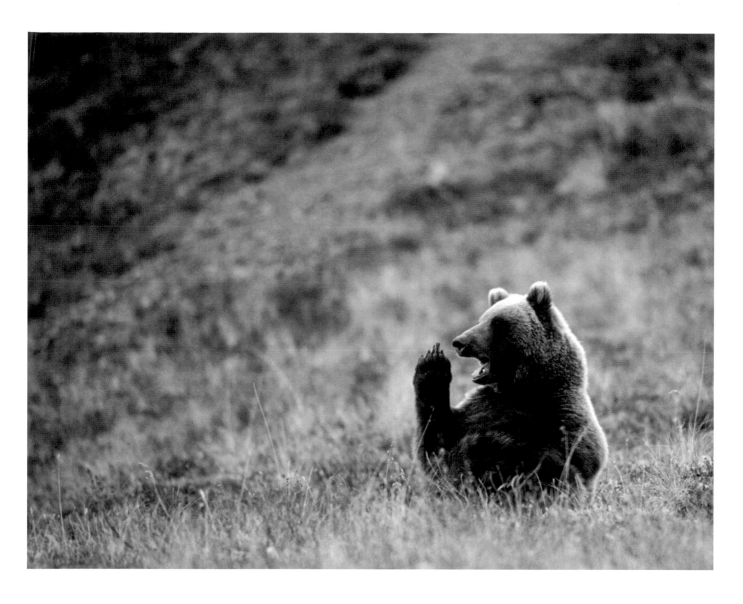

Denali National Park, Alaska

DANNY LEHMAN

Ellesmere Island, Canada

ART WOLFE

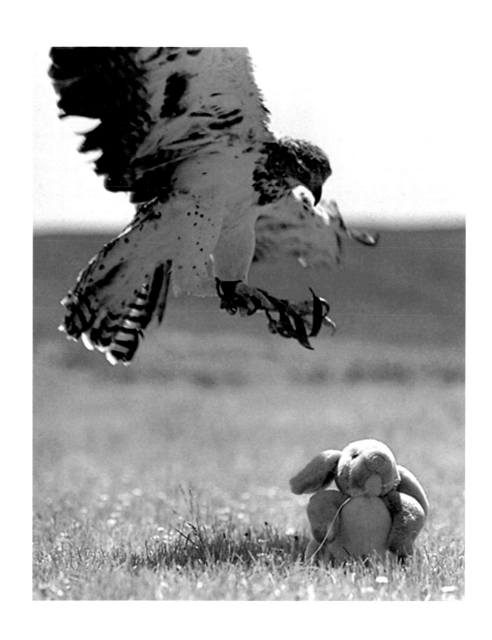

**Kent,
England**

KENT NEWS
& PICTURES

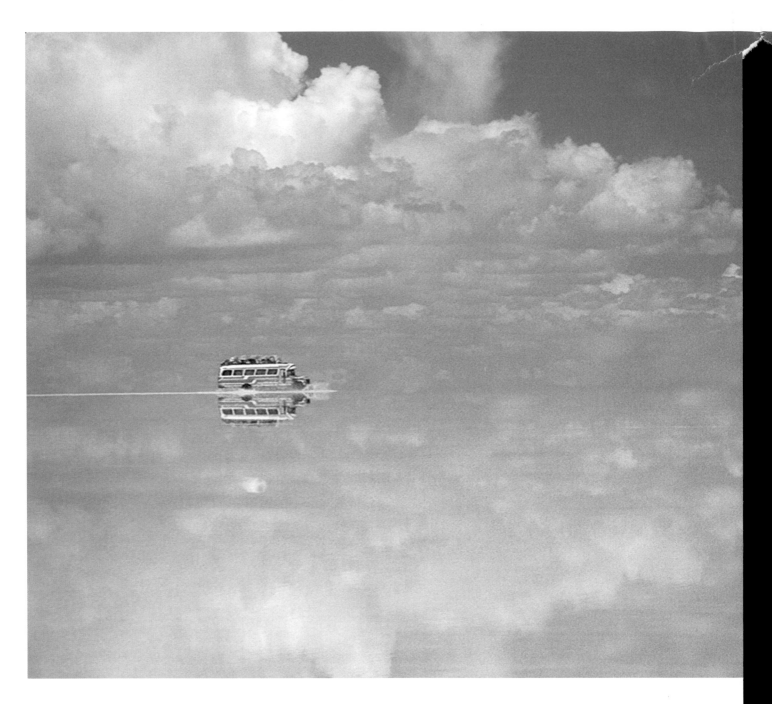

H I P - H O P H A R E S

Andes Mountains, Bolivia

MITCHELL ROGERS

Baja California, Mexico

ART WOLFE

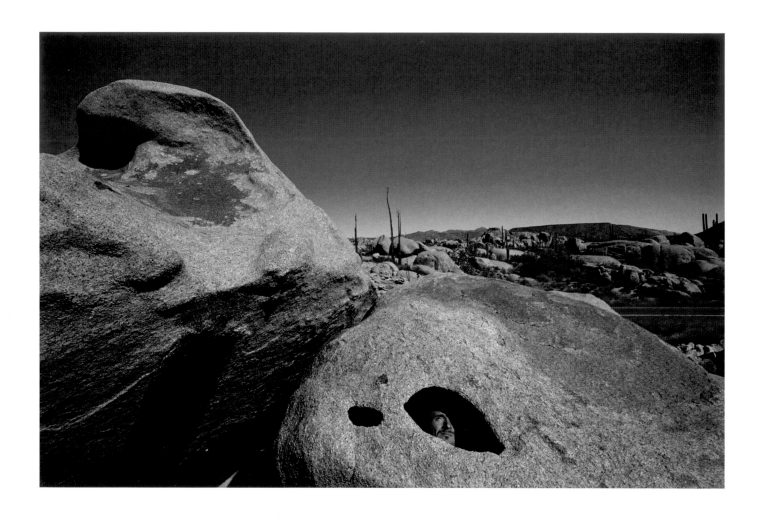

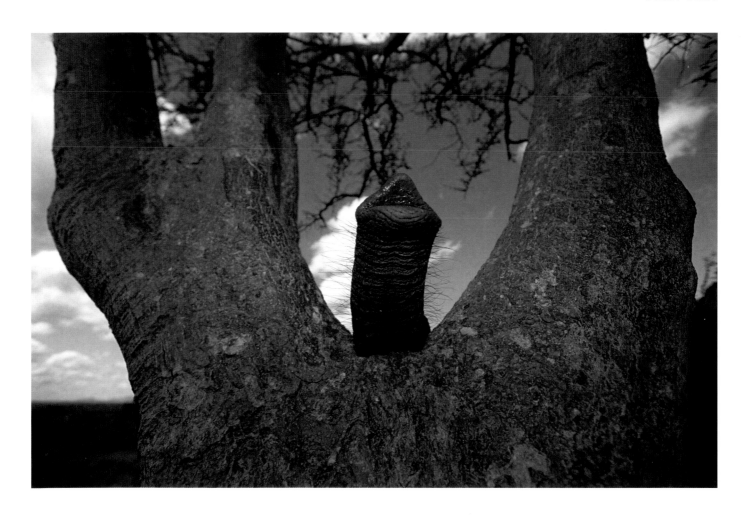

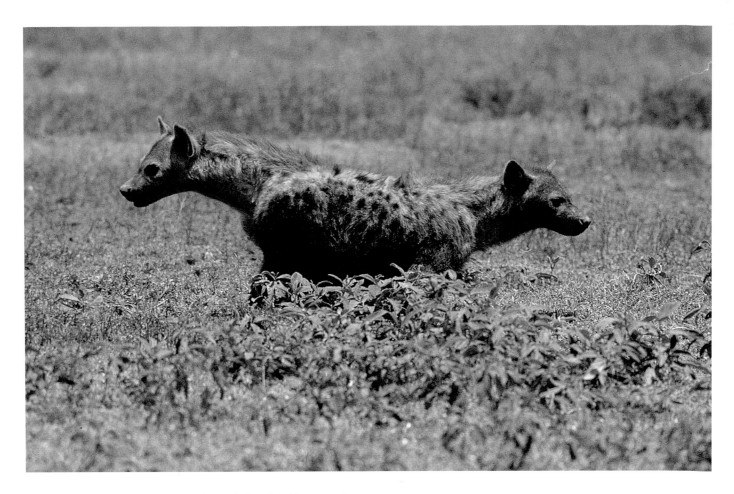

Ngorongoro Crater National Park, Tanzania

DOUG CHEESEMAN

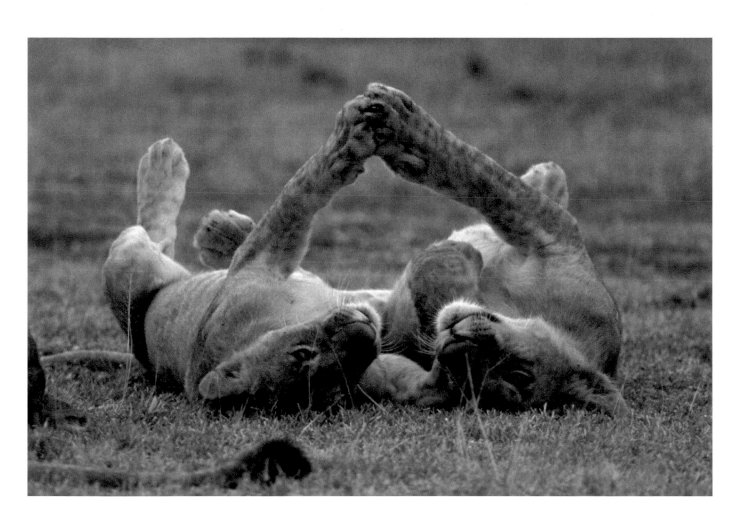

Serengeti National Park, Tanzania

GERRY ELLIS

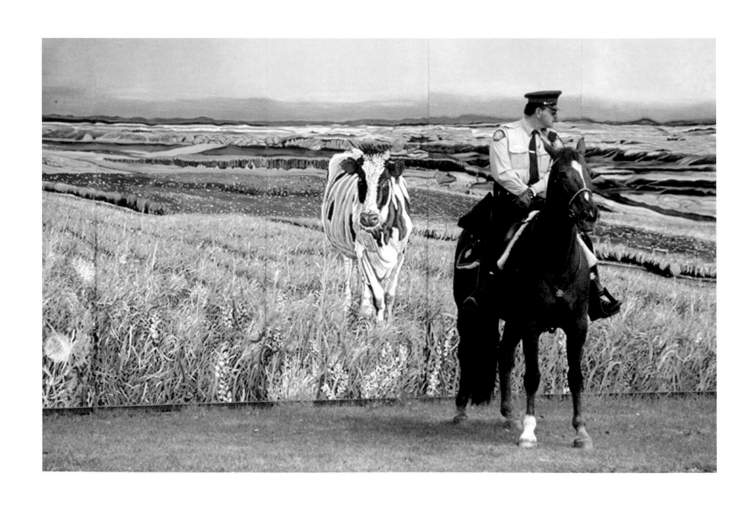

Calgary, Canada

JOHN GIBSON

Salamanca, Spain

ZÖE FALLIERS

HIP-HOP HARES

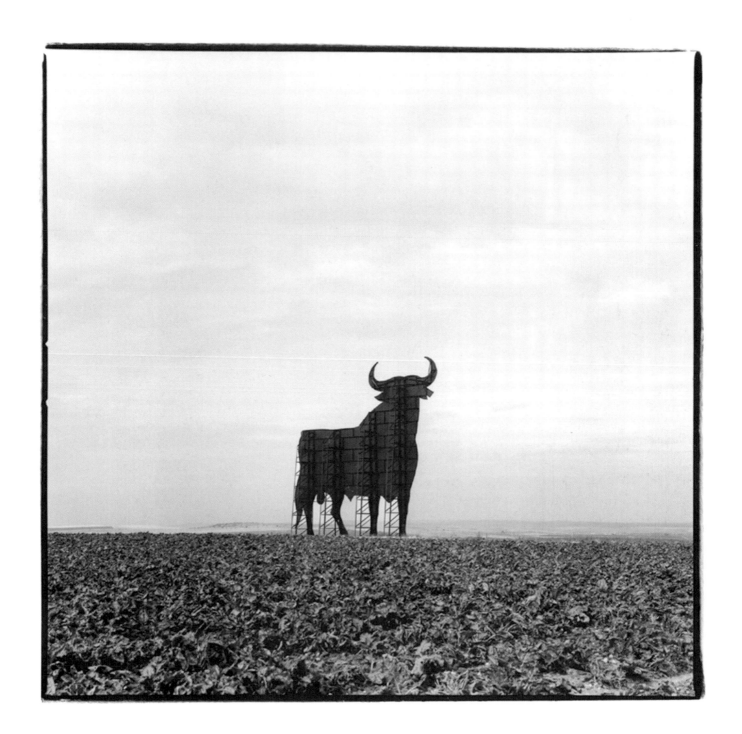

Monument Valley, Arizona

WOODS WHEATCROFT

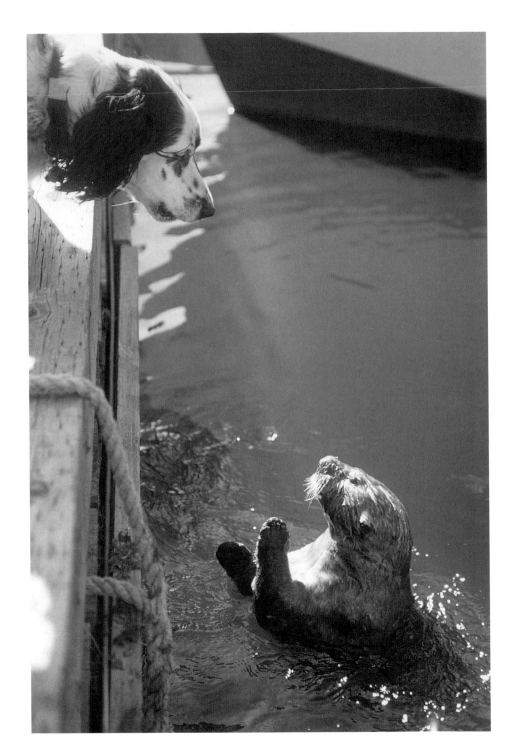

Cordova Harbor, Alaska

KEOKI FLAGG

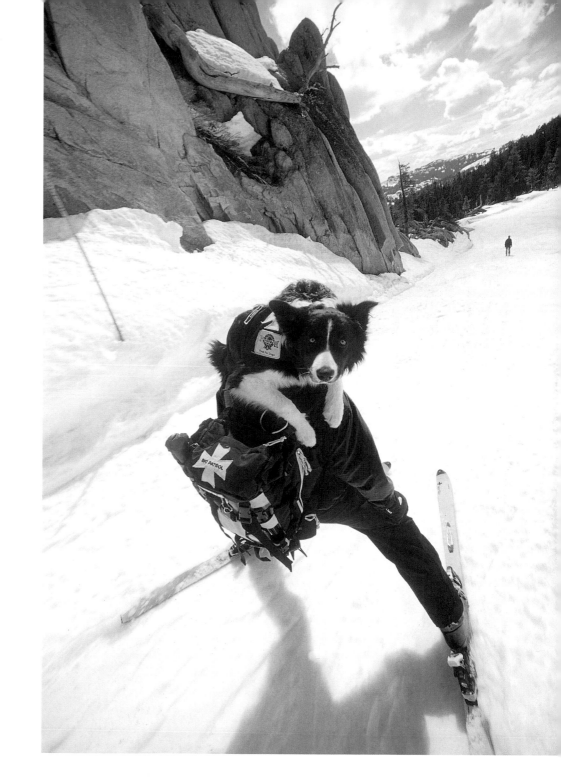

Lake Tahoe, California
KEOKI FLAGG

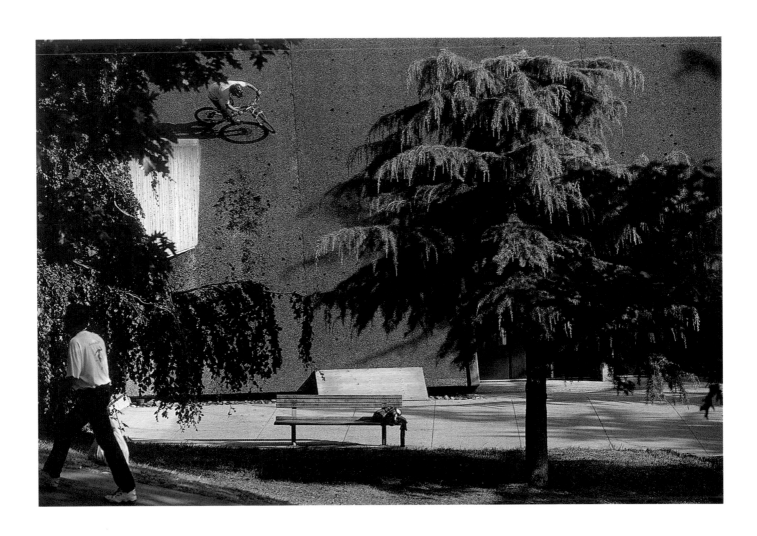

Vancouver, Canada

SCOTT SERFAS

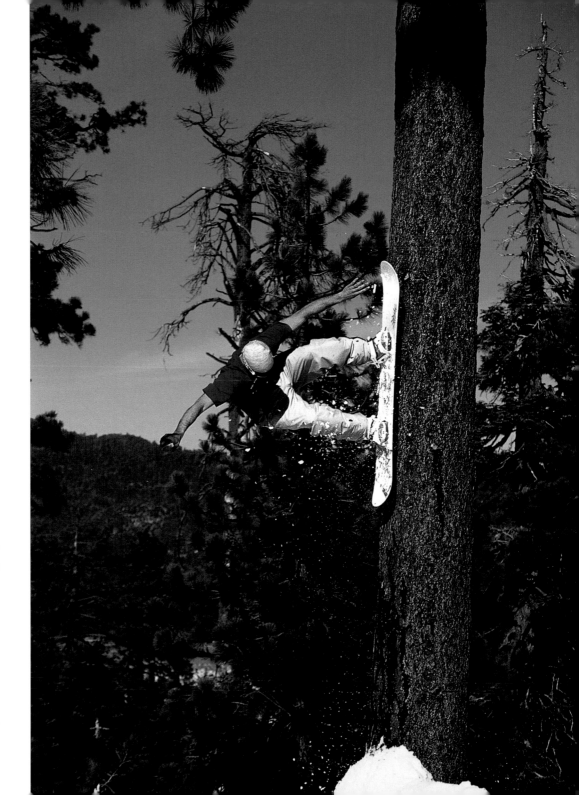

Snow Summit,
California

SCOTT SERFAS

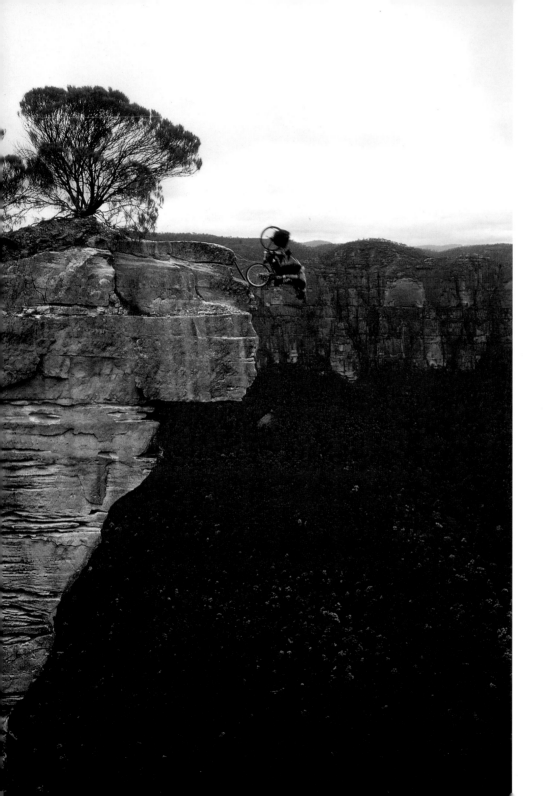

**Blue Mountains,
Australia**

MARK COSSLETT

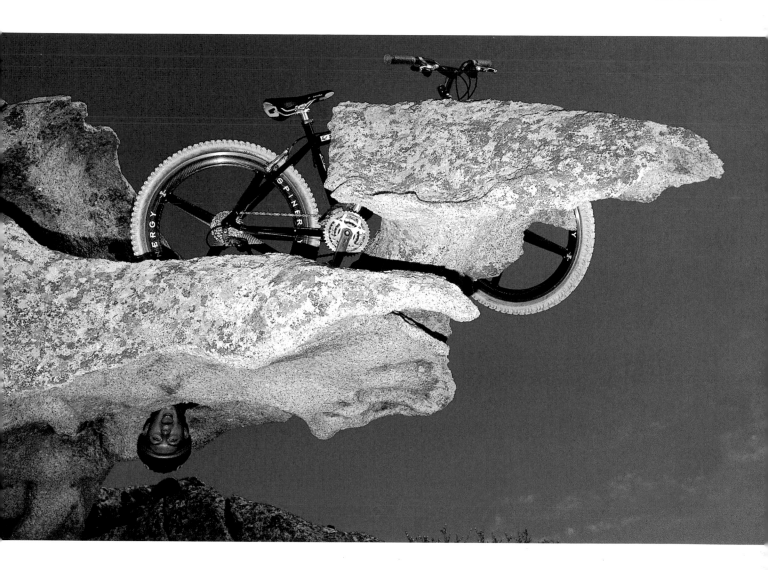

Queensland, Australia

STEPHEN WILKES

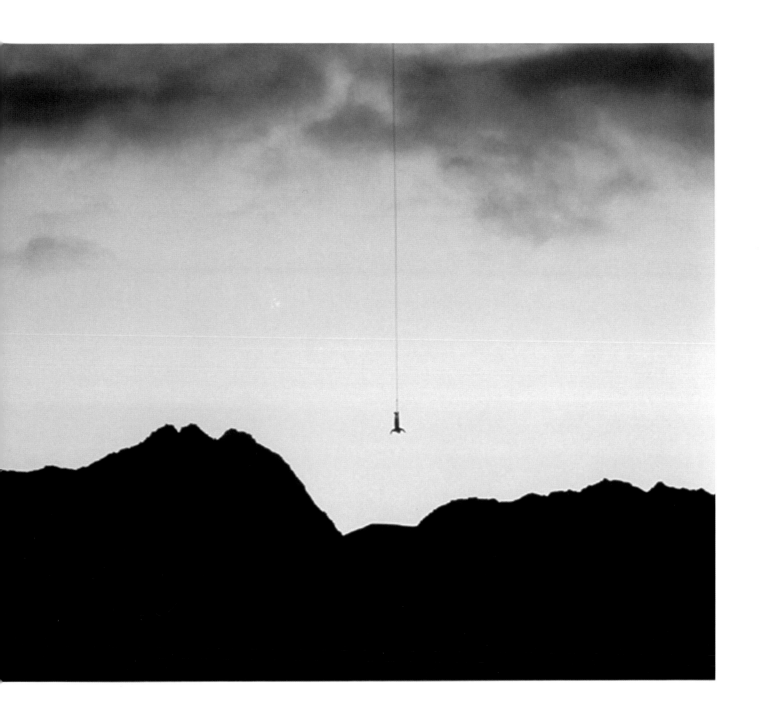

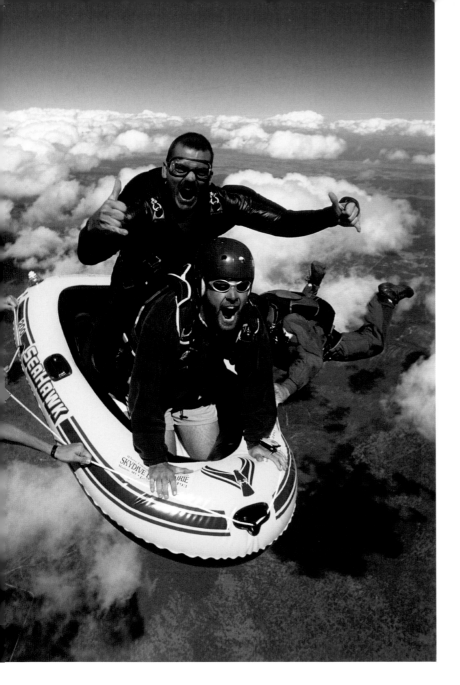

Over Lost Prairie, Montana

MICHAEL McGOWAN

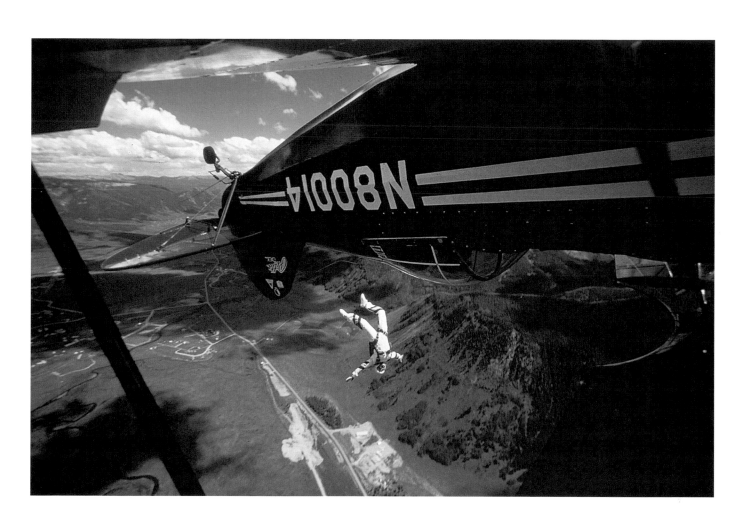

Over Crested Butte, Colorado

PAUL GALLAHER

Mammoth, California

COREY RICH

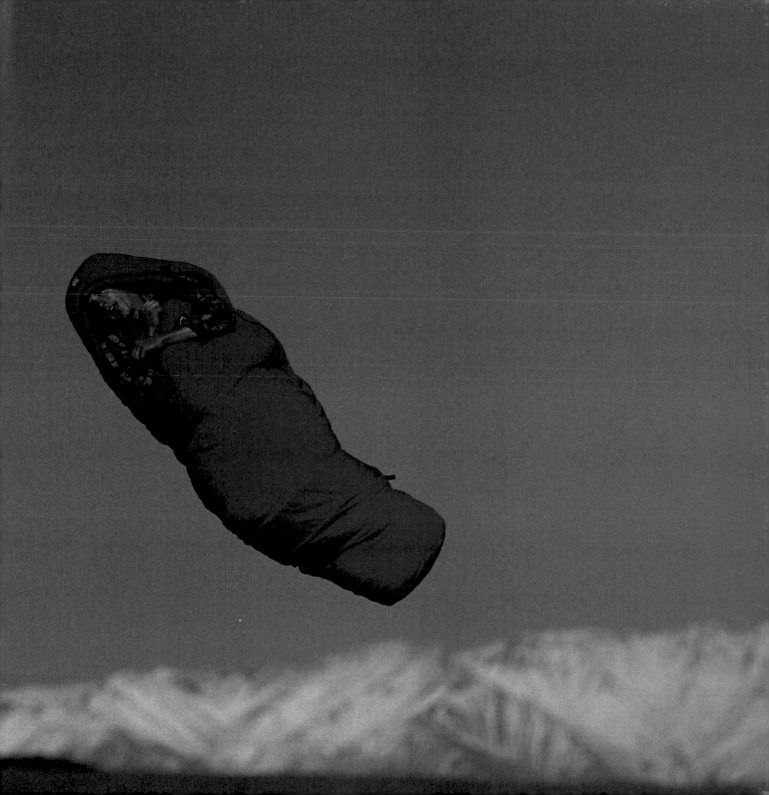

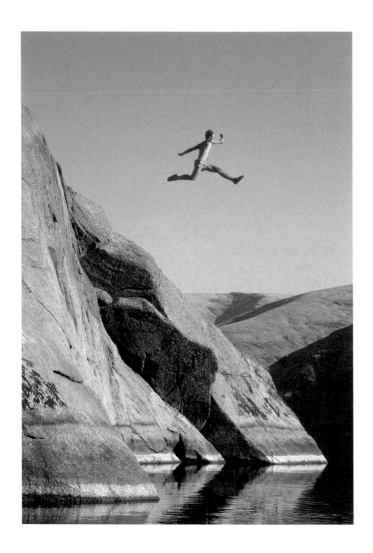

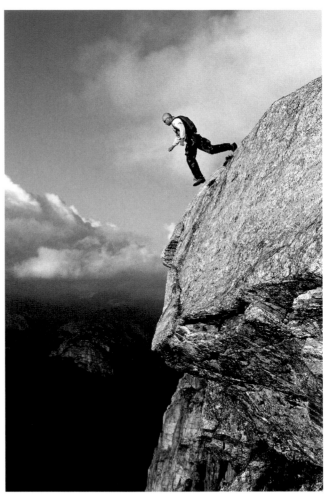

Stavangev, Norway

JONAS PAULSSON

Snake River, Washington

SCOTT SPIKER

H I P - H O P H A R E S

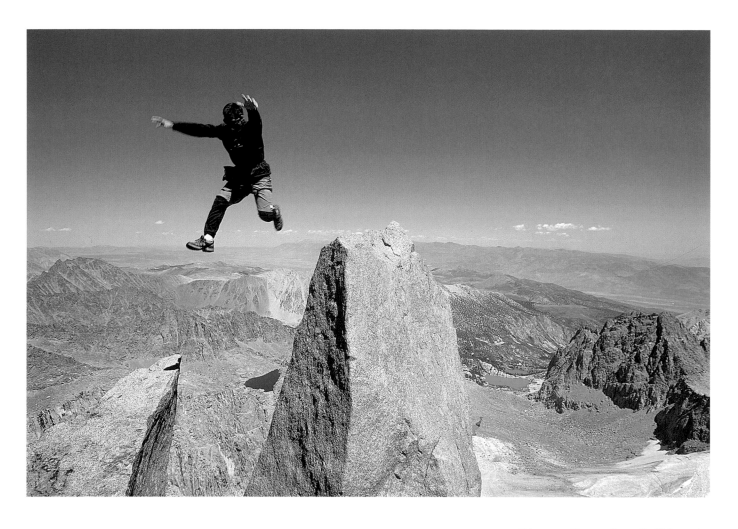

Sierra Nevada, California

DAN PATITUCCI

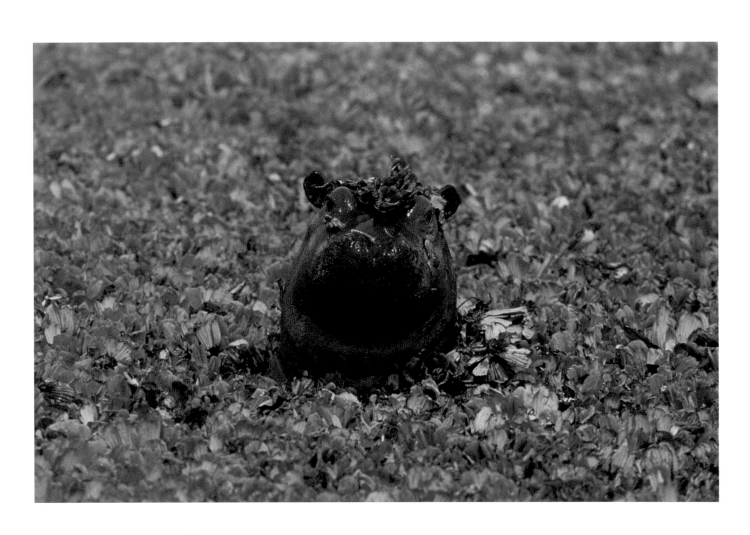

Masai Mara National Reserve, Kenya

JAMES GRITZ

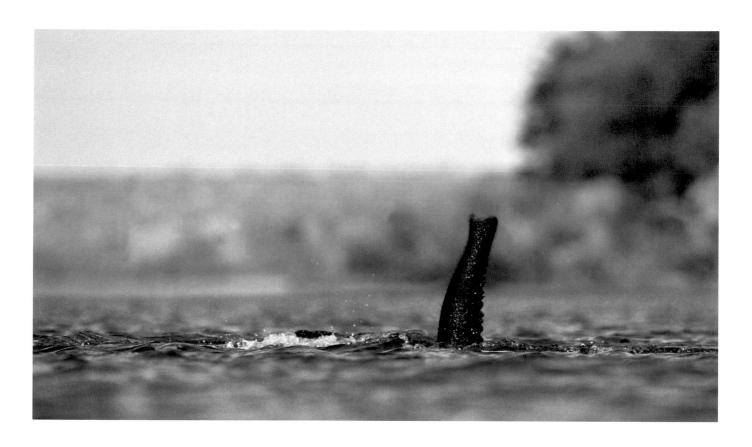

HIP - HOP HARES

Maui, Hawaii

STEPHEN WILKES

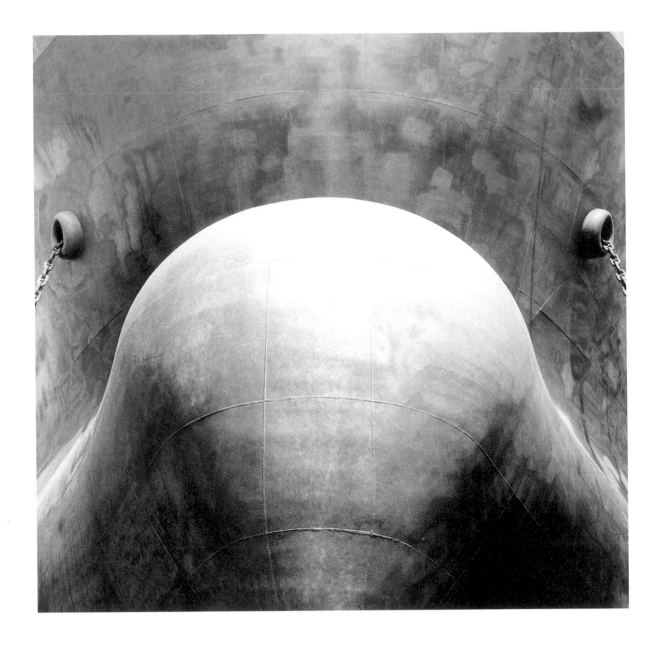

Marseille Harbor, France

ALAIN GIRAUD

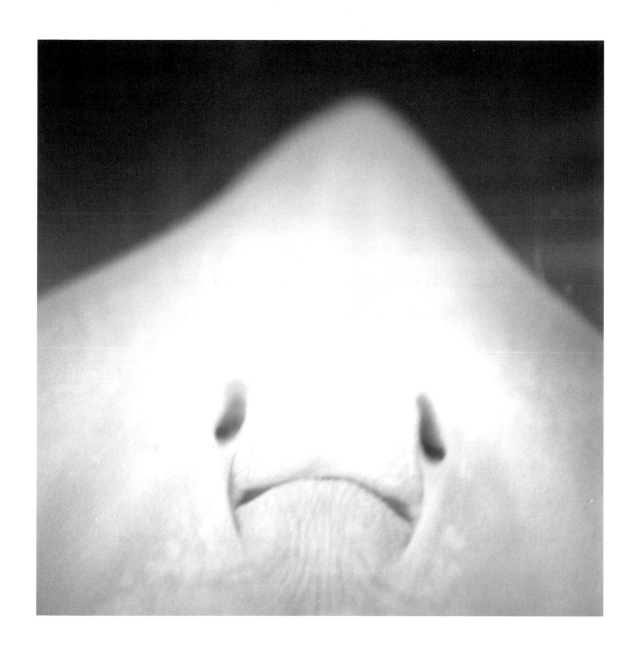

Brooklyn, New York

JAYNE HINDS BIDAUT

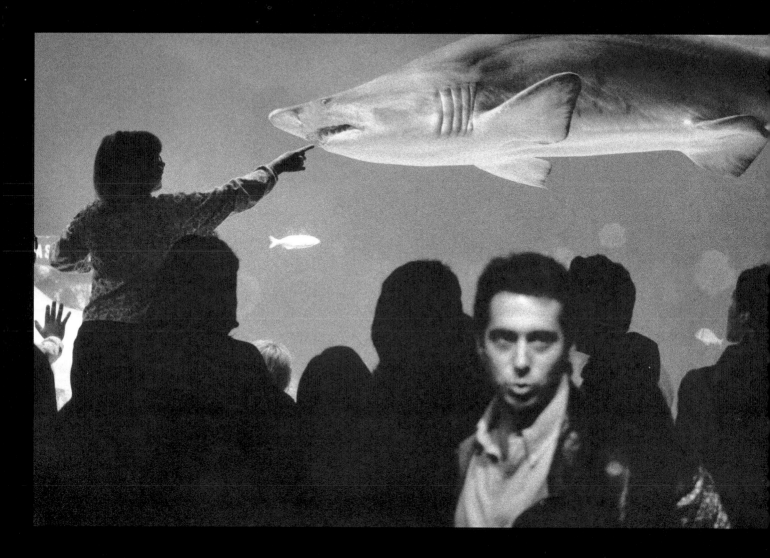

Brooklyn, New York

ELLIOTT ERWITT

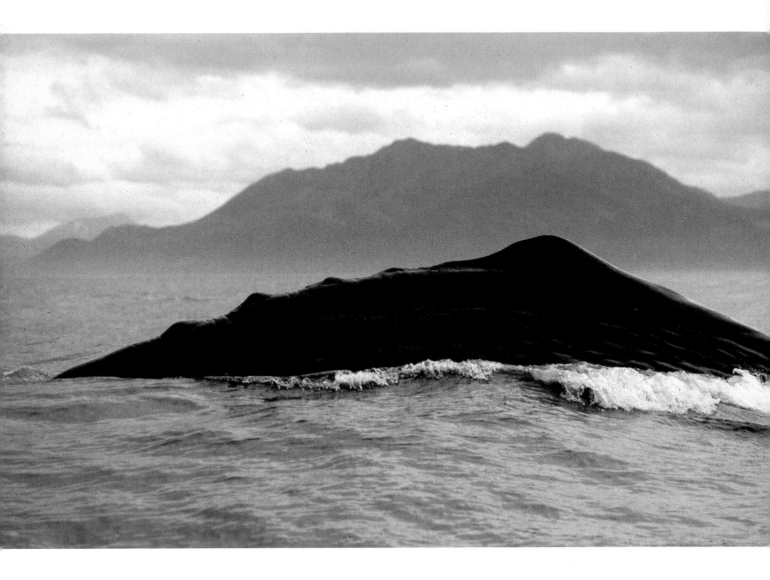

Kaikoura, New Zealand

MARK CARWARDINE

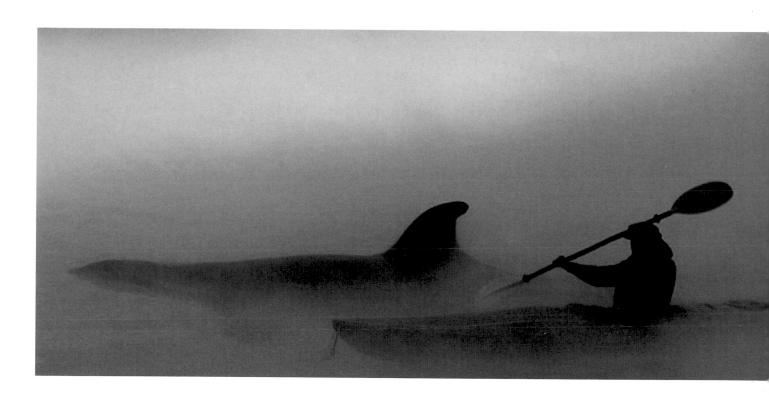

Orlando, Florida

C. BACINELLO

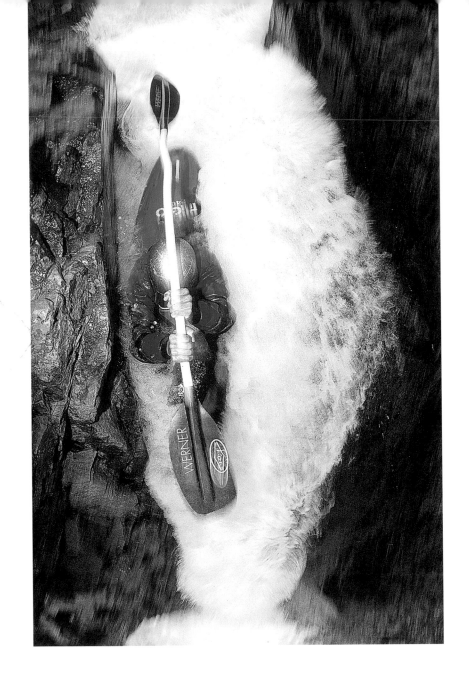

Silverton, Colorado

CAMERON LAWSON

HIP-HOP HARES

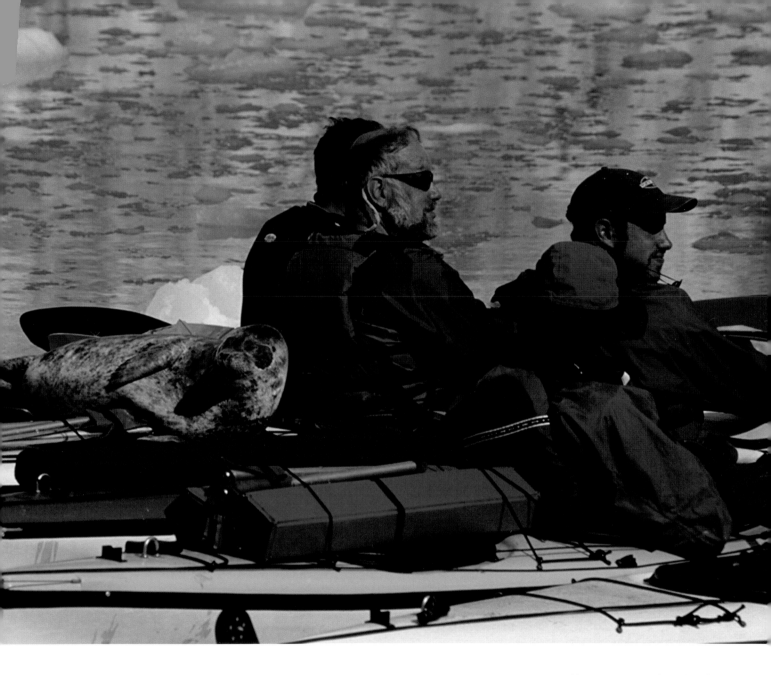

Prince William Sound, Alaska

PATRICK ENDRES

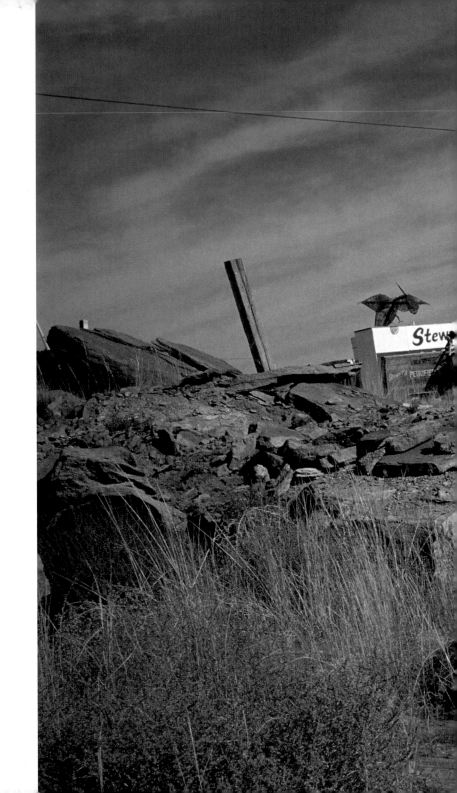

Holbrook, Arizona

DAVID BUTOW

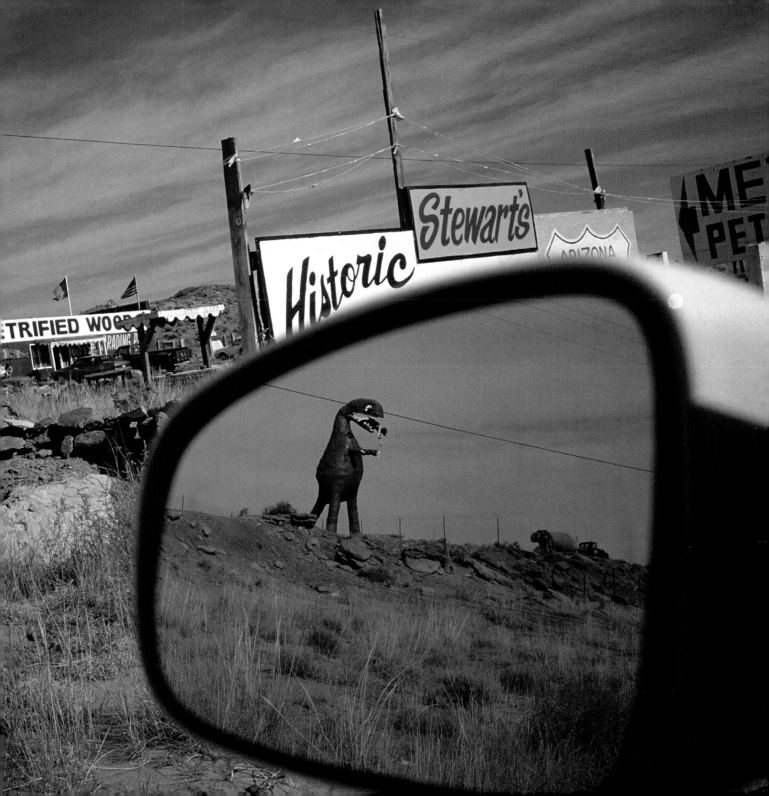

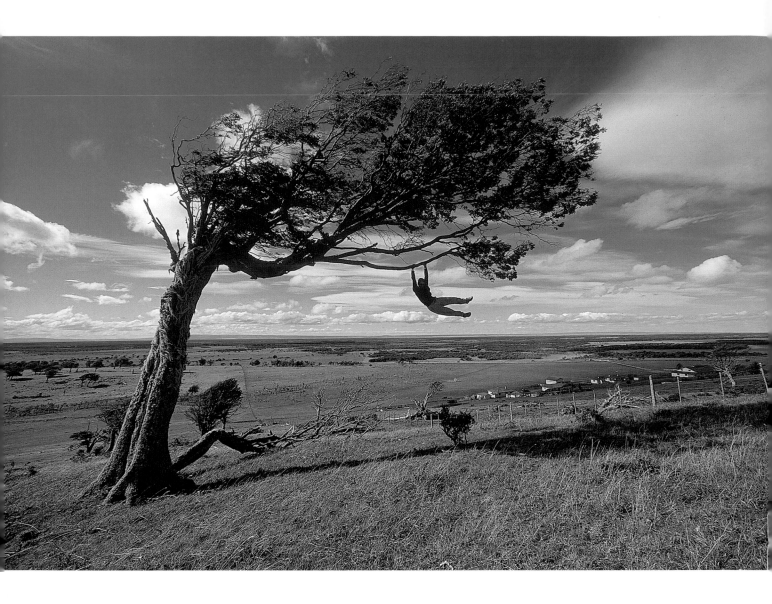

Torres del Paine National Park, Chile

WADE McKOY

HIP-HOP HARES

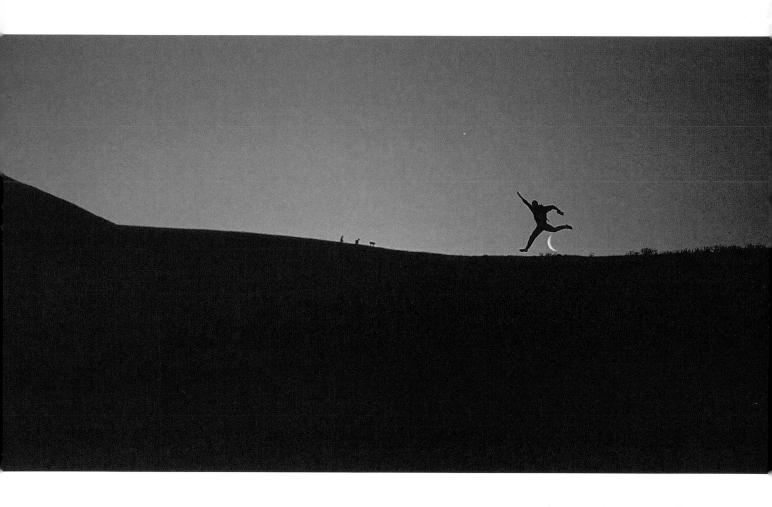

Santa Barbara Island, California

JEOF SPIRO

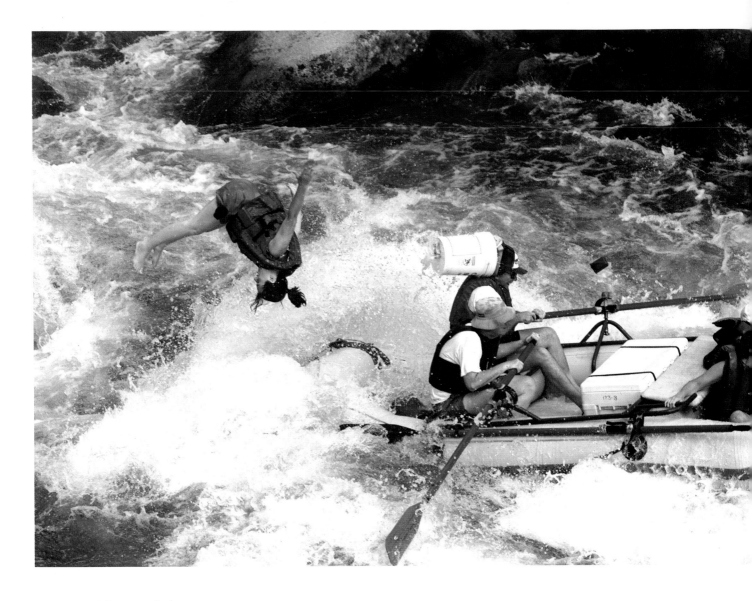

Payette River, Idaho

CHARLIE MUNSEY

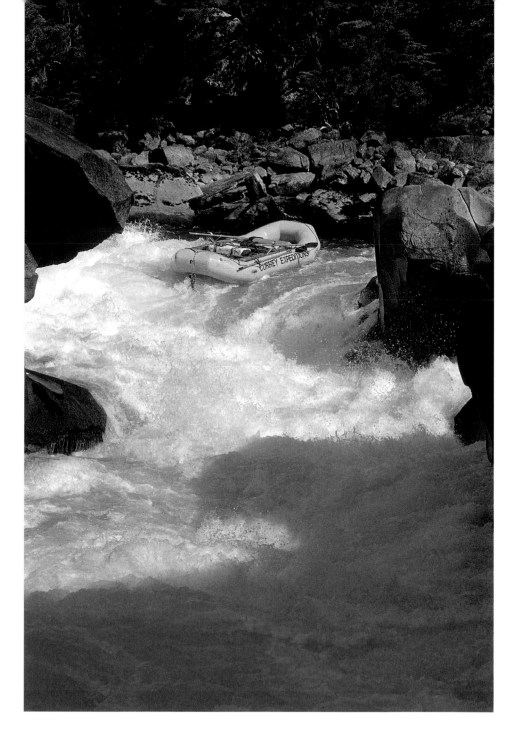

Futaleufú River, Chile

PHIL DERIEMER

Over Cape Canaveral, Florida

BRIAN ERLER

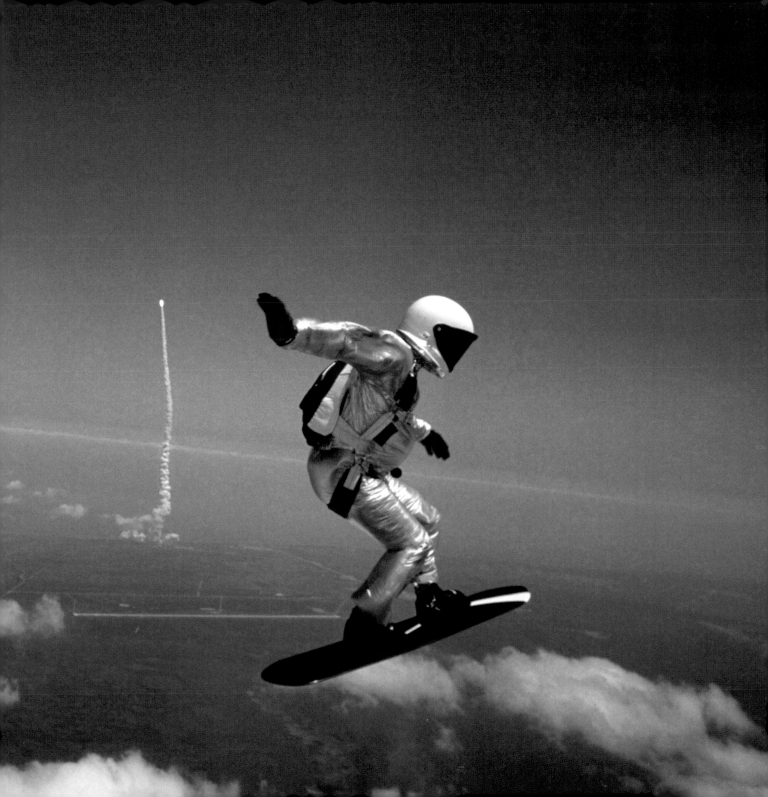

Bozeman, Montana

BOB ALLEN

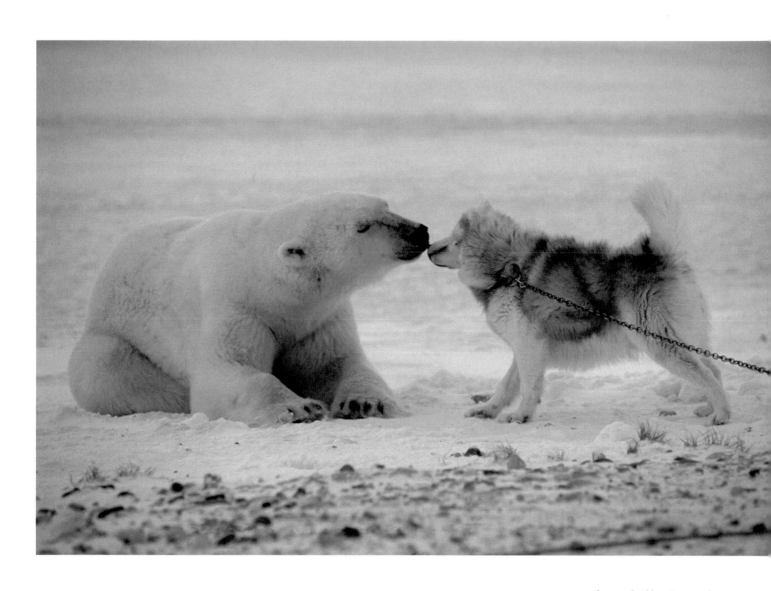

Churchill, Canada

THOMAS MANGELSEN

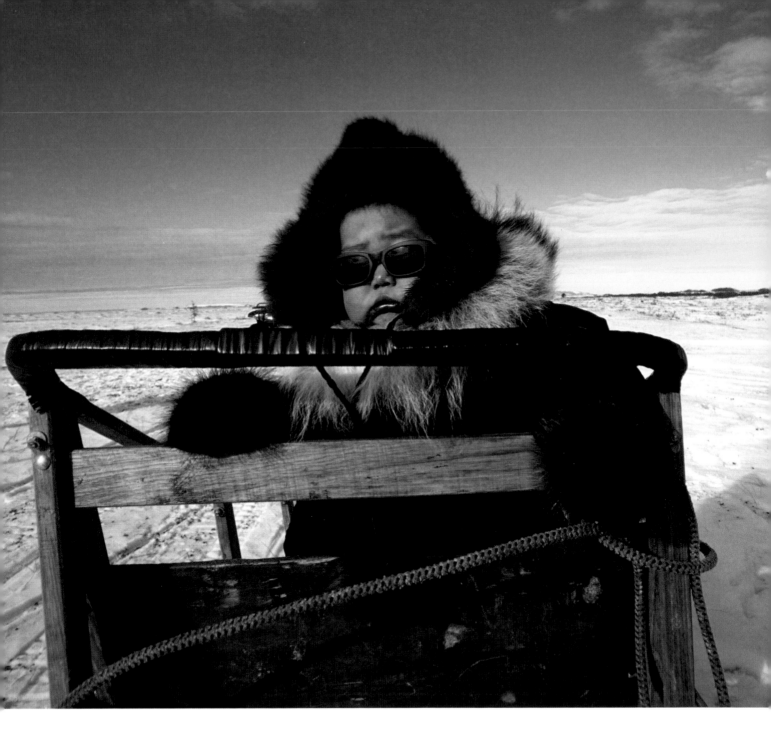

HIP·HOP HARES

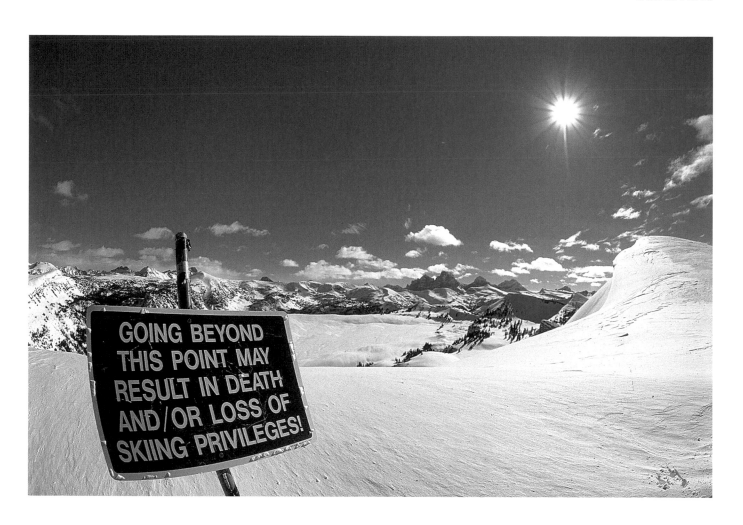

GOING BEYOND
THIS POINT MAY
RESULT IN DEATH
AND / OR LOSS OF
SKIING PRIVILEGES!

Delaware Bay, New Jersey

FRANS LANTING

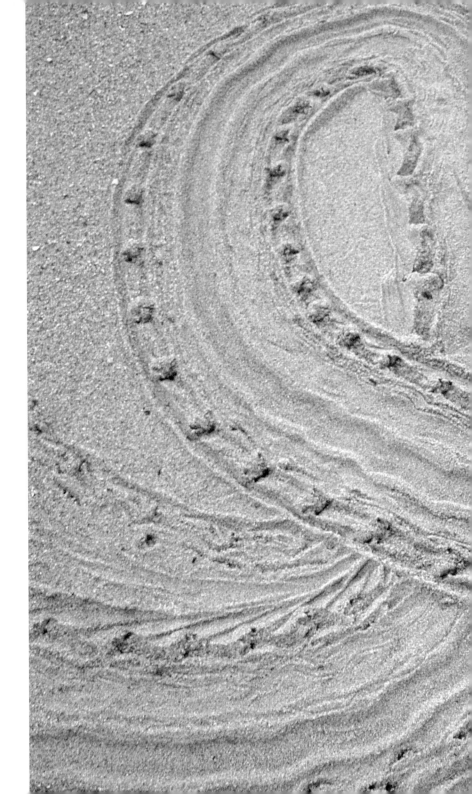

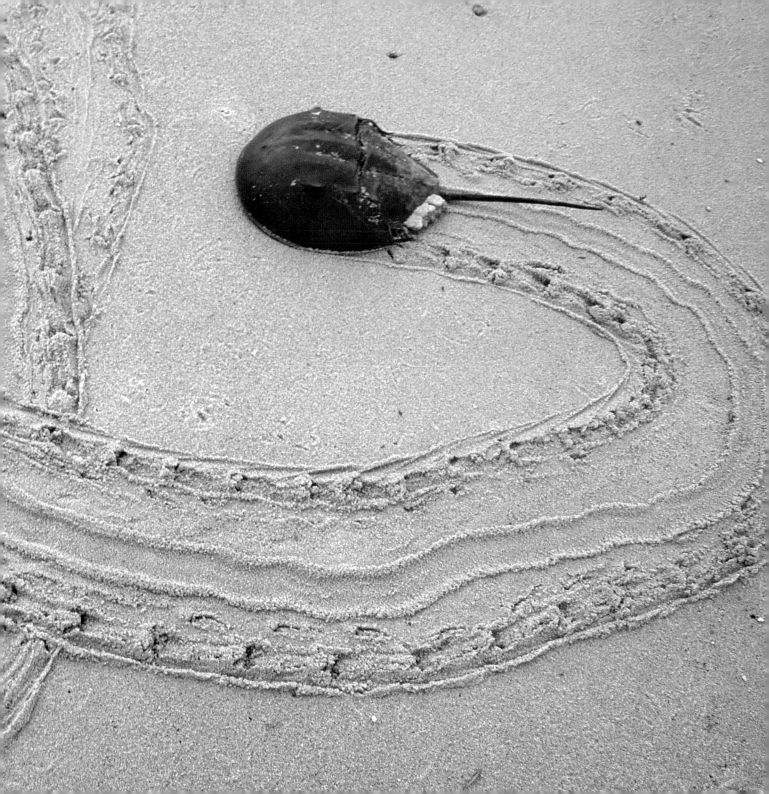

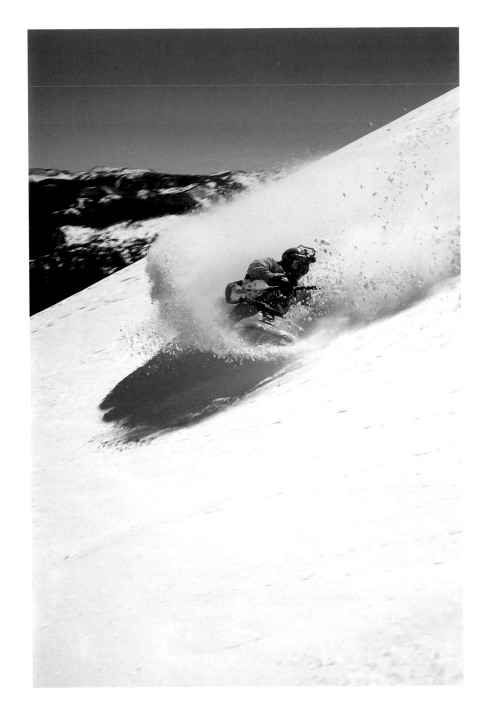

Wolf Creek, Colorado

JOHN FULLBRIGHT

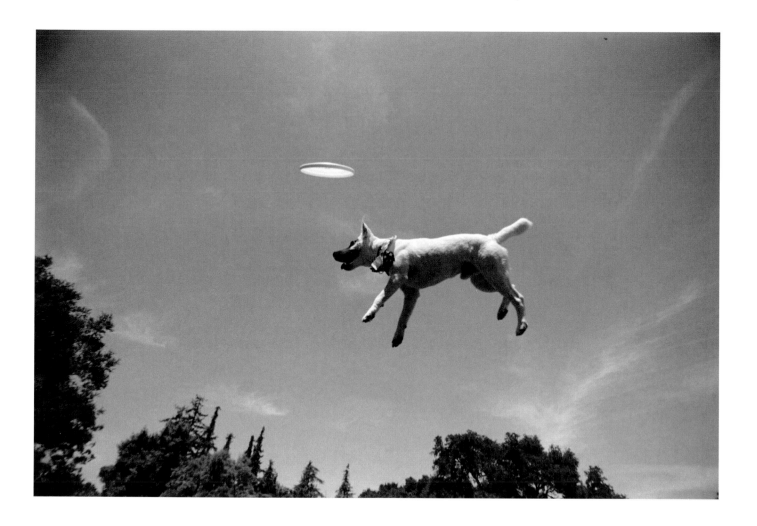

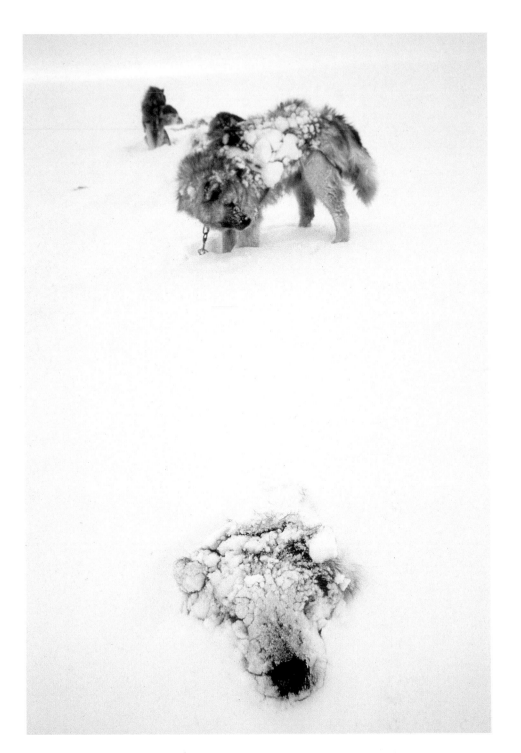

**Mirny Station,
Antarctica**

PER BREIEHAGEN

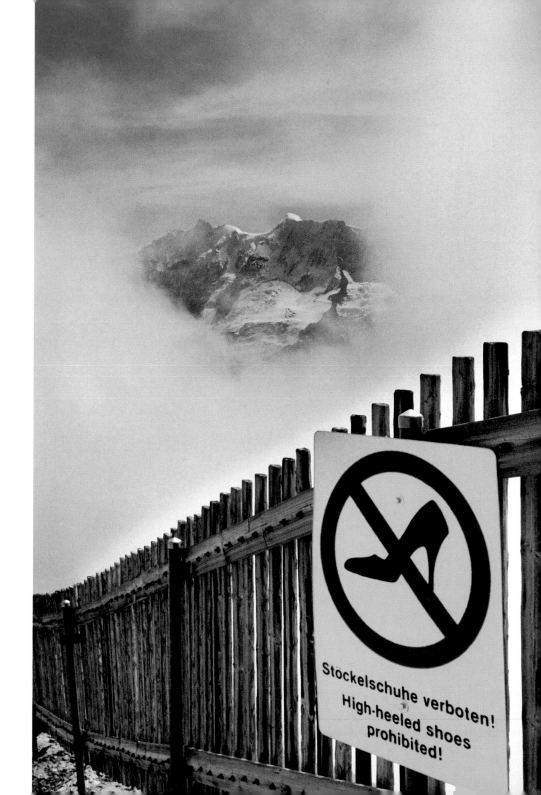

Schilthorn, Switzerland

ROB LEA

Stöckelschuhe verboten!
High-heeled shoes
prohibited!

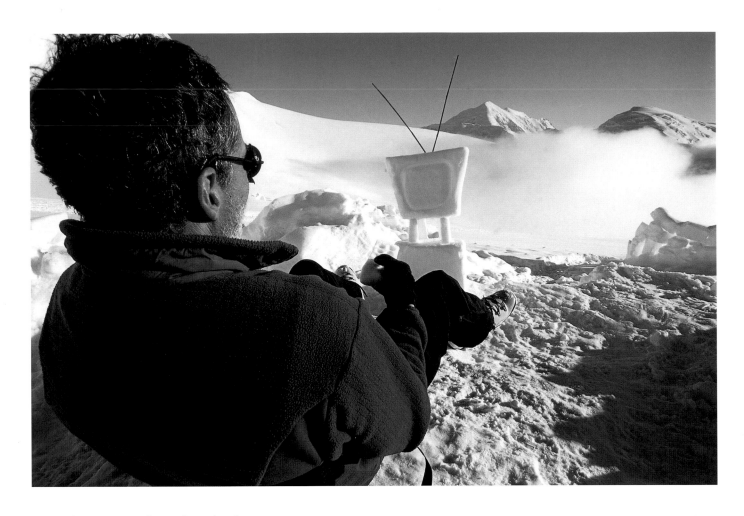

Denali National Park, Alaska

TY MILFORD

Cedar Mountains, South Africa

GORDON FORBES

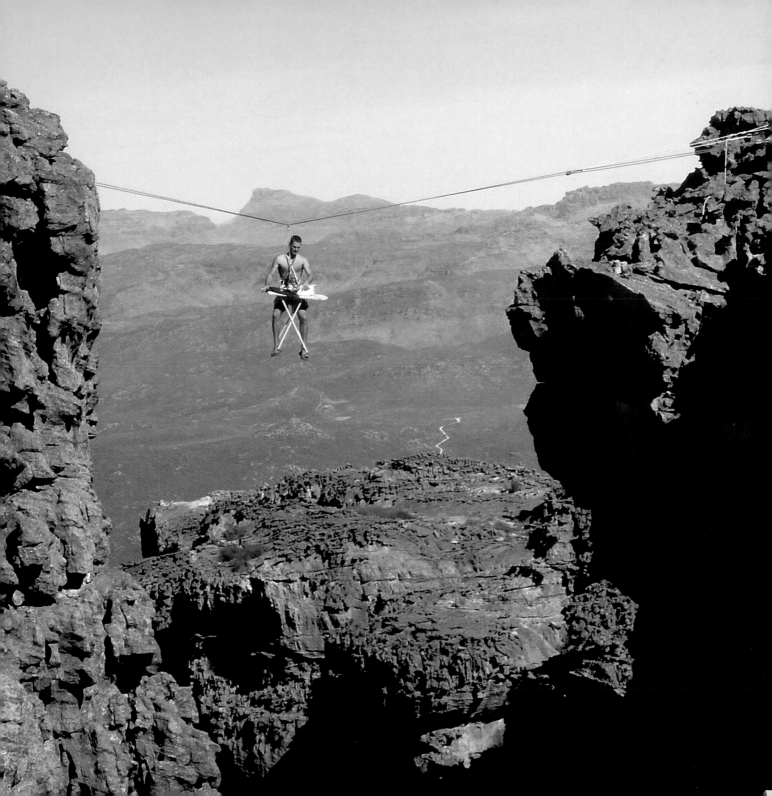

Ngorongoro Crater National Park, Tanzania

FRED BRUEMMER

HIP-HOP HARES

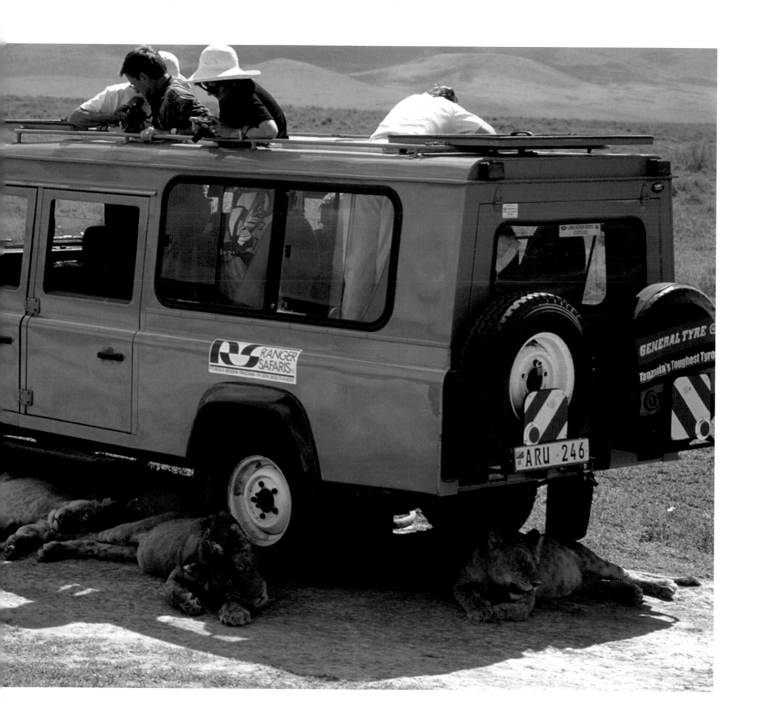

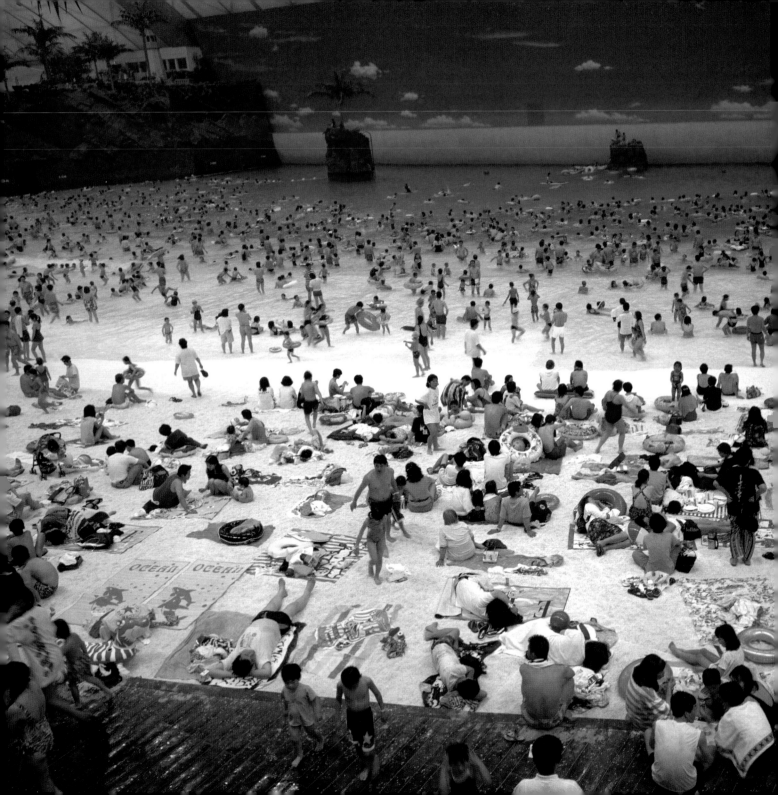

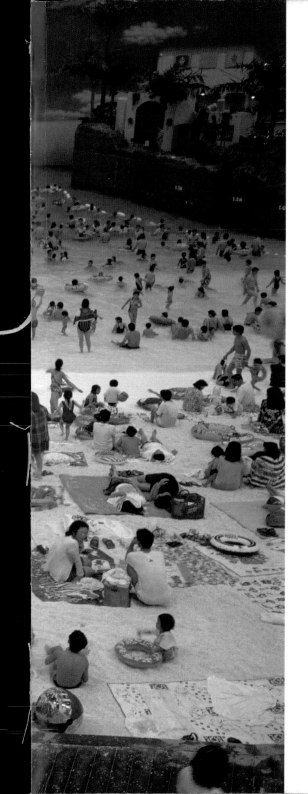

Miyazaki, Japan

MARTIN PARR

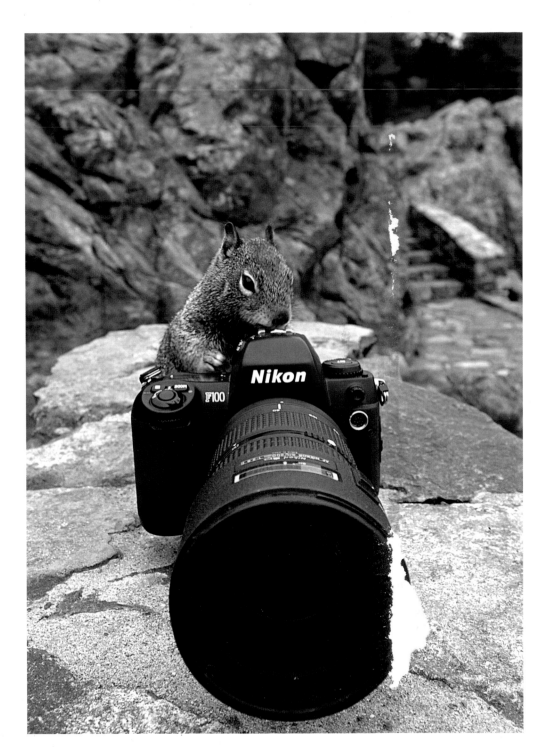

Patrick's Point State
Park, California

CHARLIE MUNSEY